**SCHOLASTIC**

**Best of Dr. Jean**

# Hands-On Art

## More Than 100 Delightful, Skill-Building Ideas and Activities for Early Learners

*by Dr. Jean Feldman*

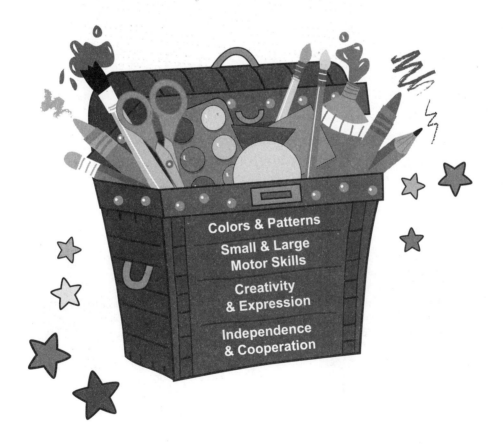

Colors & Patterns

Small & Large
Motor Skills

Creativity
& Expression

Independence
& Cooperation

NEW YORK • TORONTO • LONDON • AUCKLAND • SYDNEY
MEXICO CITY • NEW DELHI • HONG KONG • BUENOS AIRES

**Teaching** *Resources*

**To Mrs. Myers, my kindergarten and first-grade teacher**

She made me feel special and she made coming to school
the most exciting thing in my life!

My wish is that the activities in this book will instill
the same love of learning in your students!

Cover illustration by Brenda Sexton
Cover and interior design by Holly Grundon
Interior illustration by Milk and Cookies

ISBN: 0-439-59724-2
Copyright © 2005 by Dr. Jean Feldman
Published by Scholastic Inc.
All rights reserved.
Printed in the U.S.A.

1 2 3 4 5 6 7 8 9 10    40    13 12 11 10 09 08 07 06 05

# Contents

# Welcome to Best of Dr. Jean
# Hands-On Art

Through art, children express themselves and explore their world. Art provides sensory pleasure, as well as an opportunity for children to talk, share, problem-solve, develop fine-motor skills, and interact with friends. In this book, you'll discover how to set up a fantastic art center—a place where children can make choices and experiment with different media.

Adults often need to remind themselves how fleeting childhood is! It's a magical time when children can paint, scribble, mold clay, paste, and let their imaginations soar. One of the major principles underlying children's art is, "It's the process, not the product!" Children are better than we are at living in the moment; they're not worried about the finished product or what others may think of their creation. Encourage children to discuss and explain their drawings and projects. Simply stand near the child and be an interested listener, or comment on the colors, lines, shapes, and other attributes.

In early childhood, it's important to distinguish between arts and crafts. With art, we provide children with the materials, then step back and let them explore and create. With crafts, there is more emphasis on the finished product. In this book you'll find tons of ideas for simple art projects, organized by medium and technique: crayons, chalk, paint, prints, hands and feet, collage, dough, recycled materials, paper plates, and paper bags. Lastly, activities for a small-motor center help children practice and develop the skills they'll use across the whole art curriculum, and later in writing.

## Meeting the Standards

The activities in this section align with the guidelines and teaching practices recommended by the national standards as summarized by Mid-Continent Research for Education and Learning (McRel) and the National Association for the Education of Young Children (NAEYC).

**Children:**

* Understand and apply media, techniques, and processes related to the visual arts

* Know how to use structures (sensory qualities, organizational principles, expressive features) and functions of art

* Know a range of subject matter, symbols, and potential ideas in the visual arts

* Understand the visual arts in relation to history and cultures

* Understand the characteristics and merits of one's own artwork and the artwork of others
McRel Visual Arts Standards (3rd Ed.) for Kindergarten.

**In *Can You See What I See? Cultivating Self-Expression Through Art* (2003), NAEYC states:**

Over the years, educators, psychologists, and philosophers have come to appreciate the value of children's art and its important role in early childhood education. It is now agreed by many in the field that exploring and creating with art materials helps children become more sensitive to the physical environment (for instance, shape, size, and color); promotes cognitive development (decision-making, nonverbal communication, and problem solving); and increases their social and emotional development (accomplishment, individuality, independence, autonomy, appreciation of others' work, and sharing).

# Setting Up the Art Center

It's amazing what one area of the room can offer children. A great art center fosters all of these skills:

* creativity

* decision making

* sensory stimulation

* cooperation

* basic concepts (colors, shapes, patterns, sizes, and so on)

* oral language

* small and large motor skills

* problem solving

* independence

* expression

## When setting up your art area, consider these tips:

* Set up the art area on washable flooring, near a sink.

* Use old adult shirts for smocks (cut long sleeves to fit children's arms).

* Ask families to send in recycled materials (see page 6).

* Check with print shops and frame shops for paper donations.

* Store materials in boxes, tubs, self-sealing bags, detergent boxes, or plastic baskets. Label containers with words or pictures.

* Keep an "Inventor's Box" full of recycled materials. Encourage children to use their imagination to invent new things!

**NOTE:**

You'll want to model how to use the materials for each project before children begin. All of the activities in this book can be done with the whole group, small groups, or individuals. For this reason, quantities of needed materials are not always specified. Simply match the projects to the needs of your group.

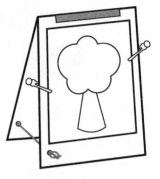

Occasionally vary where you do art by taking children to the playground, having them sit on the floor, and so on. Turn the lights off, play different styles of music, and "spark" up the environment.

Create individual portable easels (see right) so you can move the art center anywhere! Use two large pieces of corrugated cardboard (the same size). Cover each with contact paper. Duct tape the two sections together at the top, poke holes in each side, and tie string through. Attach clothespins to hold paper. Stand up on a table and use with watercolors, paints, or markers. (If you cover one side with felt, you'll have a handy flannel board as well as an easel.)

## You'll want to stock the art center with all sorts of materials. Here's a basic list:

| Recycled Materials: | Other Materials: | |
| --- | --- | --- |
| magazines | scissors | paper plates |
| junk mail | glue | paper bags in all sizes |
| wallpaper books | markers | scrap paper |
| newspaper | crayons | tissue paper |
| grocery bags | colored pencils | construction paper |
| egg cartons | chalk | envelopes |
| cardboard rollers | paintbrushes | craft sticks |
| foam packing | tape | pipe cleaners |
| old greeting cards | hole punch | computer paper |
| fabric scraps | watercolor paint | buttons |
| wood scraps | tempera paint | beads |
| wrapping paper | paper clips | wiggle eyes |
| butter tubs | brads | glitter |
| milk carton lids | crayons | string |
| | | yarn |

# Displaying
# Children's Art

Displaying children's art sends the message, "This is a place for children. We value children and their work." Children have ownership when their work is displayed. You'll want to put up all children's work (not just what came out "best").

Think of your classroom as a gallery as you showcase children's art in any of the following ways. Rotate children's work frequently to keep interest high!

## BULLETIN BOARDS

Staple children's artwork to a bulletin board. Use burlap, butcher paper, fabric, aluminum foil, newspaper, or other types of paper for the background. Highlight with borders, ribbon, paper chains, and so on.

## INDIVIDUAL BULLETIN BOARDS

Provide children each with their very own section of a bulletin board (or a surface of their cubby or locker) so they can make decisions about what they would like to display.

## CLOTHESLINES

Attach a clothesline to the walls in the classroom or in a hallway. Attach children's work with clothespins.

## BOX FRAMES

Use box lids to create a three-dimensional frame. Place children's work in the middle.

## MATS

Ask a frame shop to save leftover picture frames and mats for your classroom.

## DISPLAY BOXES

Let children paint a large, empty appliance box (such as a refrigerator box). Attach children's work to all four sides.

## MEMORY BOOKS

Save samples of children's work throughout the year to create a memory book at the end of the year.

Crayons

# Color Your Day With Crayons!

Crayons are inexpensive, readily accessible, simple to use, and easy to clean up. You'll be amazed at the variety of things you can do with a box of crayons!

## Crayon Rubbings

**Materials:** crayons, white paper, small textured objects (coins, pieces of screen, sandpaper, comb, and so on)

**How To:**

1. Remove the paper wrapping from the crayons.
2. Place a sheet of paper over the textured object.
3. Have children rub with the side of the crayon (in one direction) to reveal a pattern!

**And...**

✳ Make nature rubbings using tree bark, rocks, flowers, leaves, and so on.

✳ Make rubbings of puzzles, magnetic letters, scissors, and other school objects.

## Dancing Crayons

**Materials:** crayons, paper, music

**How To:**

1. Invite children to hold one crayon in each hand.
2. Listen to some music and tell children to let the crayons "dance" on the paper!
3. Listen to different styles of music and have children describe how the music makes their crayons "dance" in different ways.

**And...**

✳ With a small group, put a large sheet of butcher paper on the floor. "Dance" markers around the paper!

# Color Bundles

**Materials:** crayons, rubber bands, white paper

**How To:**

1. Wrap a rubber band around three or four crayons of different colors.

2. Have children hold the "bundle" and draw a design or picture on paper.

# Mirror, Mirror

**Materials:** mirror, crayons, paper

**How To:**

1. Have children look in the mirror.

2. Invite them to draw a self-portrait.

**And...**

✳ Have children sit facing a partner and draw each other's picture.

✳ Have children write names on the back of the pictures, mix them up, and guess who belongs to each portrait.

✳ Invite children to try this with a full-length mirror.

# Wash & Resist

**Materials:** crayons, heavy white paper, tempera paint (well-diluted with water), large paintbrush

**How To:**

1. Have children draw a picture with the crayons. Remind them to press hard to apply a generous amount of color and wax from the crayon.

2. Have children "wash" over the entire page with paint. The areas covered by the crayon will resist the paint.

**And...**

✳ Children can color underwater pictures or sky pictures and "wash" with blue paint.

✳ Have children make spooky pictures and "wash" with black paint.

✳ Have children write a secret message with a white crayon and let a friend "wash," and then read, the message.

Crayons

# Negative Space

**Materials:** crayons, scissors, paper

**How To:**

1. Cut a hole out of the middle of a sheet of paper.

2. Have children draw a picture incorporating the hole ("negative" space).

**And...**

✱ Have children tear holes out of a sheet of paper and exchange papers with a friend.

✱ Have children use markers or paints around the hole.

# Wiggles & Squiggles

**Materials:** crayons, paper

**How To:**

1. Have children close their eyes and make a design on paper with a black crayon.

2. Have children open their eyes and create something out of their designs.

**And...**

✱ Have children exchange wiggles and squiggles with a friend and let him or her color them in.

# Dot to Dot

**Materials:** crayons, paper

**How To:**

1. Make six to ten dots on a sheet of paper.

2. Have children exchange papers with a friend.

3. Tell children to connect the dots any way they like. What does it look like?

4. Children add details to create an object or design.

# Folded Designs

**Materials:** white paper, crayons

**How To:**

1. Have children take a sheet of paper and fold it two or three times randomly.

2. Have them open it and trace over the creases on the paper with black crayon.

3. Invite them to fill in each section with a different color, design, or pattern.

**Crayons**

# Little to Large

**Materials:** crayons, white paper

**How To:**

1. Have children make a very small shape or object in the center of the paper.

2. Have children take a different color crayon and trace around the shape or the object, making it a little larger.

3. Children continue using different colors of crayons and making the object a little larger each time until it completely fills the page.

**And...**

✷ Have children draw seasonal objects, such as hearts, kites, leaves, and so on.

✷ Invite children to do "rainbow" writing by tracing around letters and words with a different color crayon several times.

# Camouflage

**Materials:** crayons, white paper

**How To:**

1. Have children draw a large letter in the middle of the paper.

2. Children turn the paper upside down or sideways.

3. Ask, *What object, animal, person, or place does it look like?* Invite them to use crayons to camouflage the letter to make it look like something else.

**And...**

✷ Challenge children to turn the letter into something that begins with its sound.

✷ Invite children to camouflage shapes or numerals.

✷ Try this with seasonal or holiday-related shapes. For instance, make something out of "100" for a 100th day of school celebration, or make something out of a shamrock on St. Patrick's Day.

# Pass It On

**Materials:** crayons, white paper

**How To:**

1. Divide the class into groups of four or five. Have each group sit in a circle.

2. Have one child in each group take a sheet of paper and begin drawing a picture.

3. At the end of one minute, children put their crayons down and pass the paper to the person on their left. They begin drawing on their friend's paper. At the end of a minute, they pass the papers again.

4. Children continue passing until their pictures get "home" to the first drawer!

**Crayons**

# Touch & Draw

**Materials:** lunch bags, interesting objects (keys, pot scrubber, foam peanuts, candy container, hair roller, dog bone, block, and so on), crayons, paper

**How To:**

1. Have someone put one item in the bag. Don't look! Children reach in the bag and feel the object.

2. Have children draw what they think it looks like.

**And...**

❋ Have children bring an item from home in a lunch bag. Say, *Exchange your bag with a classmate's and draw each other's objects. Can you guess who drew what you brought in?*

# Class Quilt

**Materials:** crayons or markers, paper cut into 8-inch squares, hole punch, yarn

**How To:**

1. Each child decorates a square.

2. Punch holes in all four corners of the square, then tie together with yarn to make a wall hanging.

**And...**

❋ Have children decorate squares with self-portraits.

❋ Make a letter quilt, seasonal quilt, or tie-in with what you're learning about.

# Complete the Picture

**Materials:** crayons, paper, glue stick, old magazines; scissors

**How To:**

1. Cut out a large picture from a magazine.

2. Cut the picture in half.

3. Glue one of the halves to one side of a sheet of paper.

4. Invite children to complete the picture by coloring the missing half with crayons.

**And...**

❋ Have children use markers instead of crayons.

**Crayons**

# Chunky Crayons

**Materials:** old crayons, muffin pan, nonstick spray

**How To:**

1. Peel the paper off the crayons.

2. Break crayons into several pieces and put in muffin pans (use nonstick spray in the pan first). Keep different colors separate. Continue until each muffin pan is full.

3. Bake at 300°F until the crayons melt.

4. Cool. Pop out and children are ready to color!

**And...**

✳ Use plastic candy molds to make shape crayons.

# Body Art

**Materials:** large rolls of butcher or bulletin board paper, crayons and markers, scissors

**How To:**

1. Have each child lie on a piece of paper and have a friend trace around his or her body.

2. Children color and cut out the bodies.

3. Have children write "I'm special because..." on their drawing and complete the sentence.

**And...**

✳ Display at open house.

✳ Invite children to decorate their bodies to reflect what they want to be when they grow up.

✳ Have children draw what they think they look like inside. Can they add bones, heart, lungs, brains, and so on?

# Chalk It Up!

Chalk is a fun medium for young children. It's also great to use outdoors on the playground surface! With these activities you'll be developing creativity, self-expression, experimentation, and fine and gross motor skills.

## Chalk Explorations

**Materials:** colored chalk, construction paper

**How To:**

Experiment with chalk! Try rubbing it on its side, swirling it around, blending two colors together, and so on.

**And...**

* Use colored chalk on all different colors of construction paper.
* Cut paper into different shapes and decorate with colored chalk.
* Use hairspray as an inexpensive fixative.

## Sidewalk Artists

**Materials:**
colored chalk, sidewalk

**How To:**

1. Children find one square on the sidewalk to be all theirs.
2. They decorate it with chalk any way they like and sign their names!

**And...**

* Practice making shapes, writing names, and so on.
* Decorate the sidewalk for holidays and birthdays.
* Draw roads and street signs on the sidewalk and play with riding toys.

Chalk

# Homemade Chalk

**Materials:** plaster of Paris, dry tempera, paper cups, water, craft sticks

**How To:**

1. In advance, fill a cup half full with plaster of Paris.

2. Add two teaspoons dry tempera paint and stir to distribute the color.

3. Add enough water so the mixture is like a thick paste, stirring quickly with the craft stick. Let dry.

4. With children, peel off the cup. Children can draw with the chunky chalk on the sidewalk!

# Wet Chalk

**Materials:** colored chalk, construction paper, cup of water

**How To:**

1. Have children dip chalk in water.

2. Children draw on the paper. Invite them to try with different colors of chalk.

**And...**

✳ Try this with buttermilk!

✳ Have children wet the paper with a paintbrush, then draw on it with dry chalk.

# Chalk Rubbings

**Materials:** chalk, construction paper, cotton ball

**How To:**

1. Children cover a construction paper shape with lots of chalk.

2. They then place the shape chalk side up on another sheet of construction paper.

3. Tell children to hold the shape in place with one finger and brush outward onto the paper with a cotton ball.

4. Children lift up the shape!

# Painters Wanted!

Painting encourages experimentation and builds concepts about color mixing. Some children in your care may have never painted before! Model how to wet the brush and scrape it on the inside rim of the container before applying it to the paper. Demonstrate how to match up the paint on the brush with the container that is the same color.

## Primary Colors

**Materials:** tempera paint, brushes, easels, paper

### How To:

1. Have children paint with one primary color (red, yellow, or blue).

2. Children can use a second primary color to discover how to create a new (secondary) color.

### And...

* Make pastels by adding white to primary or secondary colors.

* Have children paint on different surfaces, such as newspaper or grocery sacks, and paper cut in different shapes (circles, triangles, umbrellas, leaves, and so on).

* Add lemon extract, vanilla, or other scents to paints.

## Creative Brushes

**Materials:** easels, paper, tempera paint, toothbrushes, makeup brushes, pine needles, rubber bands tied together, feathers, pieces of sponges, and so on

### How To:

1. Invite children to examine some of the unusual items that can be used as brushes!

2. Have them paint, experimenting with the different brushes.

### And...

* Create group pictures on butcher paper.

# Car Painting

**Materials:** toy cars, large sheet of butcher paper, tempera paint, paper plate

**How To:**

1. Put a small amount of paint in the paper plate. Cover a table with butcher paper.

2. Have children dip the wheels of the car in the paint, then "drive" it across the paper.

3. Have them repeat with different colors.

# String Painting

**Materials:** string or yarn cut in foot-long pieces, cups of tempera paint, paper

**How To:**

1. Have children fold a piece of paper in half and open.

2. They hold the string by one end and dip the string in the paint. They lay string on one half of the paper.

3. Children fold the paper again, then slowly pull out the piece of string.

**And...**

✳ Have children use two strings and two different colors of paint!

# Marble Painting

**Materials:** marbles, cups of tempera paint, spoon, white paper, shoe box, scissors

**How To:**

1. Cut the paper to fit the bottom of the box.

2. Have children drop marbles in the cups of paint. With a spoon, remove the marbles and place them in the box.

3. Tilt the box, rolling the marbles around to make a design.

**And...**

✳ Roll paper and place it inside a cylindrical canister. Have children drop jingle bells in paint, then spoon into the container. Put on the lid and shake. (Sing "Jingle Bells" as you shake!) Remove paper to see the jingle bell painting!

✳ Use golf balls, rocks, and other objects to paint in a similar way.

# Squishy Painting

**Materials:** tempera paint, paper, spoon

**How To:**

1. Have children fold a sheet of paper in half.

2. With the spoon, they drizzle several colors of paint on the paper.

3. Children fold in half and rub and pat to make the colors "squish" together. Open and let dry.

**And...**

✳ Children can cut a large butterfly or heart shape from paper and use this technique to decorate it.

✳ Children can drizzle paint on one sheet of paper, then put a second sheet on top and roll over the surface with a rolling pin!

# Cotton Swab Painting

**Materials:** cotton swabs, tempera paint, paper plates, paper

**How To:**

1. Put a little paint on each paper plate.

2. Have children dip the ends of cotton swabs in paint and use as brushes.

**And...**

✳ Mix several drops of food coloring in two tablespoons of water and have children paint with cotton swabs on paper towels.

✳ Invite children to make patterns with dots.

# Mud Painting

**Materials:** soil, water, plastic container, brushes, paper

**How To:**

1. Mix the soil with water to make a thick liquid.

2. Have children paint a picture with brushes—or with fingers!

**And...**

✳ Look for different types of soil to create different shades of mud paint.

# Bubble Painting

**Materials:** mixing bowl, dish detergent (Joy works well), straw, water, food coloring, white paper

**How To:**

1. Put about one cup of water in the bowl. Add a squirt of dish detergent.

2. Children can take turns using a straw to blow bubbles in the bowl.

3. When the bubbles start overflowing, put several drops of food coloring onto them, then lay the paper on top. The bubbles will pop and create a design!

# Finger Tray Painting

**Materials:** plastic lunchroom trays, finger paint, finger paint paper, water, sponge

**How To:**

1. Put heaping tablespoons of paint right onto the trays. Children can finger-paint on the trays! Invite them to make designs with fingers, knuckles, or fists.

2. Help children wet the finger paint paper with a sponge.

3. Show children how to lay the paper on top of the tray, press, and see the finger paint design appear. Lift and let dry.

**And...**

✳ Cut the paper into seasonal shapes or designs.

✳ Mix two primary colors to make a secondary color.

✳ Make your own finger paint by adding dry tempera to liquid starch.

✳ Have children finger paint with instant chocolate pudding!

✳ Have children finger-paint with shaving cream on tables and desks. It's a great way to clean them!

# Glue Globs

**Materials:** white school glue, food coloring, white paper plates

**How To:**

1. Squirt about two tablespoons of glue in the middle of the paper plate.

2. Add a drop of red, yellow, and blue food coloring in different corners of the glue glob.

3. Have children tilt the plate slowly around to create new colors and designs with the glue. Let dry.

**And...**

✳ Children can use toothpicks or cotton swabs to move the colors around.

Paint

# Flour & Salt Painting

**Materials:** flour, salt, tempera paint, brushes, cotton swabs, construction paper

**How To:**

1. Mix equal parts of flour and salt (about 1/2 cup each).

2. Stir in tempera (about one cup) until the mixture is thick. (Add a little more water if it's too thick to paint with.)

3. Invite children to paint with brushes, cotton swabs, or fingers!

**And...**

✳ Mix orange paint, salt, flour, and some pumpkin pie spice (nutmeg, allspice, cinnamon). Then paint pumpkins!

# Water Painting

**Materials:** large brushes and rollers (the kind house painters use), pails or large plastic containers

**How To:**

1. Fill containers with water. Let children paint with water all over the playground!

2. Paint the outside of the building, playground equipment, sidewalk, pavement, whatever!

3. Together, observe how the water evaporates.

**And...**

✳ This works well on chalkboards and is a great way to get them clean!

✳ Try this on a hot day.

# Watercolor Mosaic

**Materials:** paper, watercolor paint, brushes, scissors, construction paper, glue

**How To:**

1. Have children paint a whole page with watercolors. Let dry.

2. Let children cut the painting into small pieces, arrange them into a collage on construction paper, then glue in place.

Prints

# Printmaking

Printmaking helps children develop concepts of shape, pattern, and even science! Printing involves the transfer of an image from one surface to another.

## Sponge Prints

**Materials:** sponges, scissors, tempera paint, paper plates, paper

**How To:**

1. Cut sponges into different shapes (letter and numeral sponges are also available in educational supply stores and catalogs).

2. Pour a small amount of paint on the paper plate.

3. Have children dip the sponge in the paint and press on the paper.

**And...**

✳ Children can use a sponge ball (a sea sponge, available in drugstores) to make prints.

✳ Have children make wrapping paper by sponge painting on craft tissue or bulletin board paper.

## Printing Tips

✳ Fold a paper towel and put it in a tray or paper plate. Pour just a small amount of paint on the paper towel so paint will be evenly distributed.

✳ The less paint used, the clearer the print will be.

✳ Teach children the basic printing technique of "press, pat, and lift!"

## Nature Prints

**Materials:** paper plate, paint, paper, leaves, flowers, pine branches, feathers, and other found natural objects

**How To:**

1. Put a small amount of paint on the paper plate.

2. Let children dip one side of the leaf or object in the paint, then apply it to the paper. Keep printing until there is no more paint on the leaf.

# Bubble Wrap

**Materials:** bubble wrap, tempera paint, paintbrushes, paper

## How To:

1. Let children paint a design on the bubble wrap.

2. Show children how to lay a piece of paper on top and gently rub across it with their hands.

3. Children lift to see a print!

# Gadgets & Toys

**Materials:** paint, paper plate, paper, spools, kitchen utensils, plastic animals or figures, and other gadgets with interesting textures.

## How To:

1. Let children dip the gadgets in the paint and print on the paper.

2. Children can dip the feet of plastic animals or figures in the paint and let them "walk" across the page.

## And...

✳ Invite children to make block prints with different sizes and shapes of blocks.

# Fruits & Vegetables

**Materials:** oranges, lemons, apples, carrots, celery, green pepper, okra, and other firm fruit or vegetables; paint; paper plates; paper towels; paper

## How To:

1. Cut fruits and vegetables in half.

2. Drain on a paper towel (or set aside for a day) to eliminate excess juice.

3. Put paint on the paper plate. Invite children to dip vegetables in the paint and press on the paper.

## And...

✳ Cut a potato in half. Carve a simple design into the "printing surface" of the potato. Pat off moisture with a paper towel, then let children dip in paint and print.

# Cookie Cutters

**Materials**: cookie cutters, tempera paint, paper plate, paper

**How To**:

1. Pour a small amount of paint on the paper plate.

2. Let children dip cookie cutters in the paint and then press on the paper.

3. Repeat with different colors!

**And...**

✳ Color in the shapes once the paint has dried.

✳ Use holiday cookie cutters to make cards or wrapping paper.

# Marshmallow Prints

**Materials**: marshmallows, food coloring, six paper cups, water, paper

**How To**:

1. Put a little water in each cup.

2. Add several drops of food coloring to each cup so there are six different colors.

3. Have children dip the marshmallow in the colored water and then print on the paper. (Cleaning up is easy—just eat it up!)

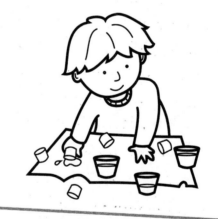

# Coffee Filters

**Materials**: water-soluble markers, coffee filters, white paper, spray bottle filled with water

**How To**:

1. Have children draw designs on the coffee filter with markers.

2. Show them how to place the coffee filter flat on the paper, then squirt with water.

3. Let dry. Children can then lift to see the design.

**And...**

✳ Cut the dyed coffee filters to create butterflies, flowers, or snowflakes.

# Tissue Paper Fade

**Materials:** tissue paper (not fadeless), white paper, spray bottle filled with water

**How To:**

1. Have children tear or cut the tissue paper into small pieces or shapes and lay them on the white paper. They can overlap.

2. Spray with a small amount of water. Dry.

3. Children can lift to see a colorful design where the tissue paper has faded.

**And...**

✳ Cut tissue paper into simple fish shapes, leaves, flowers, or other seasonal objects.

# Fingertip Prints

**Materials:** ink pad (washable, nontoxic ink), paper, fine-tip markers

**How To:**

1. Tell children to press a finger or thumb on ink pad and print on paper.

2. Children can use fine-tip markers to create animals, people, flowers, insects, and other objects out of fingerprints.

**And...**

✳ Challenge children to try using different fingers, especially pinkies!

# Fabric Prints

**Materials:** paper plates, tempera paint, different types of cloth into squares (felt, burlap, velvet, wool, and so on)

**How To:**

1. Put paint in the paper plates.

2. Let children dip one side of one of the fabric squares into the paint.

3. Have children experiment with "painting" and "printing" on paper.

4. Repeat with different types of fabric.

**And...**

✳ Once dry, challenge children to guess which type of fabric made each print.

# Hands On! Feet On!

Children's handprints and footprints can make some of the best keepsakes of these early years. Some of these projects are for individual children, while others need several children to lend a hand or foot! Either way, they're a perfect display for a bulletin board or classroom door. Invite children to try creating any of the images on the following pages.

## Some Ideas

✳ Trace around children's hands and cut them out of construction paper.

✳ Let children dip their hands or feet in paint or trace hands and feet onto construction paper, and cut out.

✳ Adapt these ideas for decorating T-shirts, sweatshirts, or book bags. Fabric paints and pens are available at art supply stores.

✳ Let children color or decorate their work. Paper scraps, markers, and wiggle eyes are great for many of these!

**dog**

**friends**

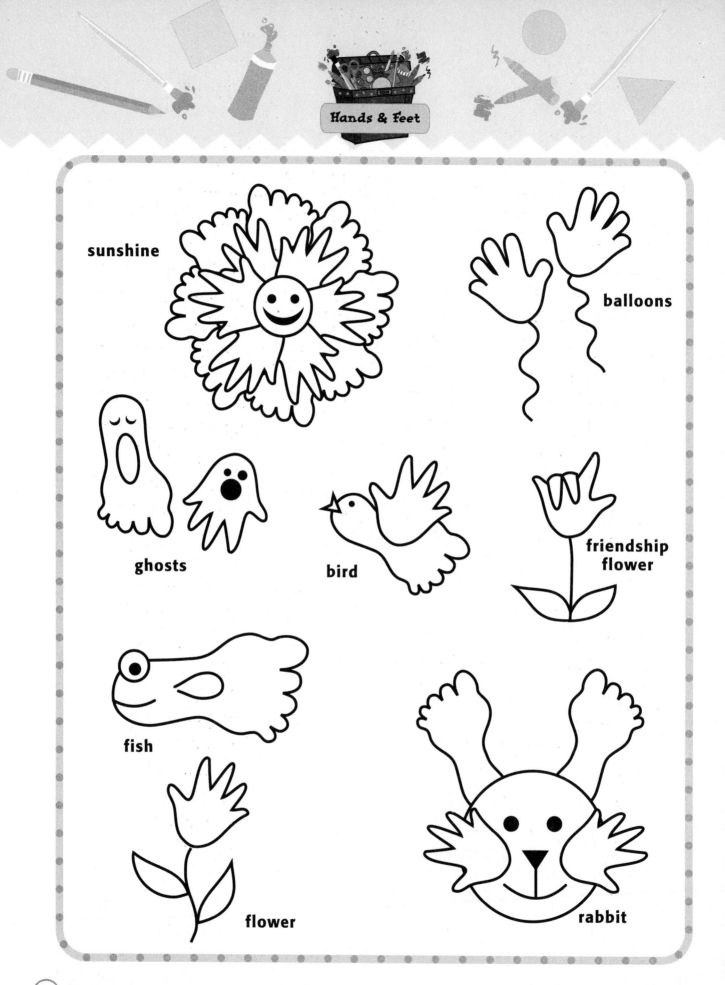

sunshine

balloons

ghosts

bird

friendship flower

fish

flower

rabbit

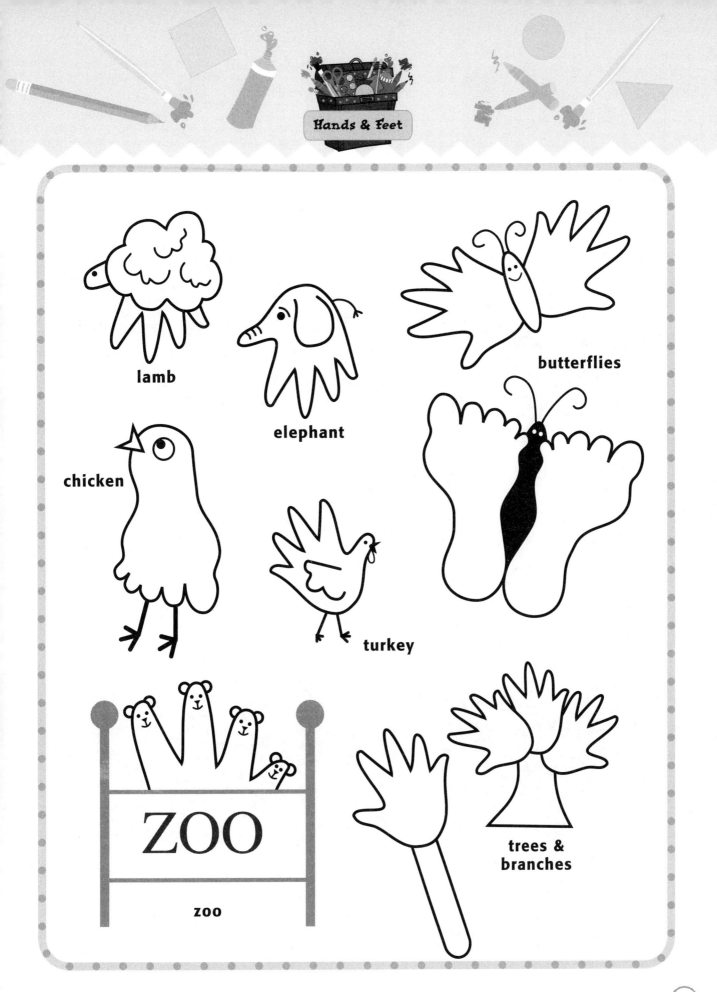

lamb

elephant

butterflies

chicken

turkey

ZOO

zoo

trees & branches

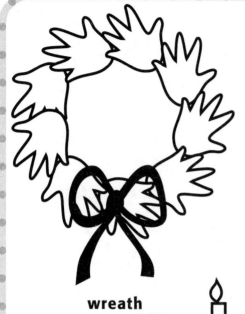

**wreath**

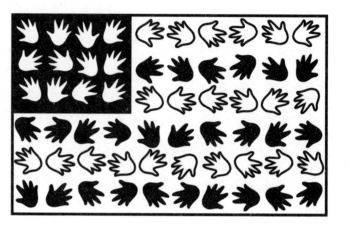

**flag**

**menorah**

**Santa**

**reindeer**

**tree**

Collage

# Creative Collage

Making collages builds awareness of recycling, encourages experimentation, and nurtures creativity and self-expression. Plus, the materials you can use are limitless! You can glue materials onto paper, lunch sacks, paper plates, wood, fabric, or any other porous surfaces.

## Tips

When working with glue, show children how to use "one finger" (for a finger-length line of glue), "one dot" (for a tiny bit of glue), or how to "dip and put" (dip something into a pool of glue and then press onto paper).

## Torn Paper

**Materials:** scrap paper, glue, construction paper, crayons and markers

**How To:**

1. Have children use their hands to tear scrap paper into little pieces.

2. Children glue them to paper to make a design or picture.

3. When dry, let children add details with crayons or markers.

**And...**

✴ Cut paper into seasonal shapes, such as eggs or leaves.

## Mother Nature

**Materials:** paper bag, objects from nature, glue, cardboard

**How To:**

1. Take a nature walk and invite children to collect small objects. (Take only nonliving objects, like fallen leaves, pinecones, acorns, and pebbles, off the ground. They should be light and smaller than your hand.)

2. Have children arrange the objects on the cardboard, then glue in place.

# Shiny Things

**Materials**: shiny objects (sequins, Mylar balloons cut into small shapes or pieces, aluminum foil, tinsel), self-laminating sheets, construction paper (optional)

### How To:

1. Have children arrange the shiny objects on the sticky side of a self-laminating sheet.

2. Children can cover with a second clear sheet, or with construction paper.

### And...

✸ If using two clear sheets, hang these in a window!

# Spaghetti Art

**Materials**: cold, cooked spaghetti, three or more self-sealing bags, food coloring, construction paper

### How To:

1. Put a little spaghetti in each bag and add a few drops of food coloring to each. Shake.

2. Let children arrange the spaghetti on the paper. When dry, it sticks to the paper.

### And...

✸ Have children dip pieces of yarn in liquid starch and arrange on wax paper. Dry, then have children lift off the wax paper.

# Letter Collage

**Materials**: paper; glue; collage materials such as rice, beans, toothpicks, feathers, yarn, confetti, and so on

### How To:

1. Have children write a letter of the alphabet on a sheet of paper.

2 Let children trace over the letter with glue, then add collage materials.

### And...

✸ Use materials that begin with the sound of the letter (beans on B, yarn on Y, toothpicks on T, and so on).

# Pizza Collage

**Materials**: paper plates, crayons, glue, oregano, basil, garlic powder, and other seasonings

### How To:

1. Have children draw a pizza on the paper plate. They can add any toppings they like!

2. They can add tiny drops of glue, then sprinkle with seasonings!

**Collage**

## Magazine Art

**Materials:** old magazines and catalogs, scissors, glue, paper

**How To:**

1. Have children cut pictures from the magazines or catalogs.

2. Let children glue to paper.

**And...**

✳ Cut out pictures of people who represent family members.

✳ Have children make a collage of likes and dislikes, things to be thankful for, things that begin with a particular sound, favorite foods, and so on.

## People Collage

**Materials:** paper, wiggle eyes, yarn, fabric, crayons, markers, scissors, glue

**How To:**

1. Use cut-out shapes similar to the one at right. Tell children to decorate their "bodies" to look like themselves.

2. Let children cut clothes from fabric, use yarn for hair, add wiggle eyes, and so on.

**And...**

✳ Have children make self-portraits using collage materials on paper plates.

## Texture

**Materials:** glue; paper; objects with different textures, such as cotton, sandpaper, velvet, corrugated cardboard, and so on, cut in 8-inch squares

**How To:**

1. Invite children to touch the textured squares and describe how the different things feel.

2. Let children choose different textures and glue them on the paper. They can label each with a corresponding adjective (*soft, smooth, rough,* and so on).

## Big Shapes

**Materials:** construction paper cut in the shape of pennants, hearts, stars, or seasonal objects; collage materials; glue

**How To:**

Have children decorate the paper shapes with collage materials.

# Squish & Mold Dough

Working with dough is a perfect way to develop fine motor-skills and creativity. It can also be a great energy release, and many children find the tactile experience soothing. Let children play with dough and clay on plastic place mats or lunchroom trays. Add cookie cutters, play dishes, birthday candles, and other cooking props. Make these doughs as a whole group, then let children play with the dough individually.

## Homemade Play Dough

**Materials:**

2 cups flour

1 cup salt

2 tablespoons cream of tartar

2 tablespoons vegetable oil

2 cups water

food coloring

**How To:**

1. Mix all the ingredients together in a pan and stir until smooth.

2. Cook over medium heat, stirring constantly, until the mixture forms a ball and sticks to the spoon.

3. Cool and knead. Store in plastic bags or covered containers.

### And...

✳ Put dough in the microwave until warm, and give to a child who could use some quiet time!

✳ Add mint, vanilla, almond, or other extracts to play dough to give it a fragrance.

✳ Use 2 tablespoons baby oil in place of the vegetable oil.

✳ Make a surprise. Follow the recipe, omitting the food coloring. Take small pieces of dough and roll them into balls. Poke a hole in each and add a drop of food coloring to the middle of each ball. Pinch to seal in the color. Children knead the balls and—surprise!

# Kool-Aid Play Dough

**Materials:**

1 package Kool-Aid

1 tablespoon oil

1/2 cup salt

2 cups boiling water

2–3 cups flour

**How To:**

1. Mix the first four ingredients together.

2. Slowly stir in the flour until dough is a smooth consistency.

3. Store in a self-sealing bag.

# No-Cook Dough

**Materials:**

3 cups flour

1 cup salt

1 cup Joy dish detergent

1 1/4 cups water (approximately)

food coloring

**How To:**

1. Mix all ingredients together.

2. Store in a self-sealing bag or covered container.

# Ornament Dough

**Materials:**

1 cup flour

1 cup salt

1/2 cup water

**How To:**

1. Mix the ingredients to make dough.

2. Mold the dough or flatten so it is 1/2 inch thick. Cut with cookie cutters.

3. Let the dough dry for a day. Turn the dough over and dry one more day.

4. Paint with tempera paint and spray with shellac.

**And...**

✳ Dissolve 2 tablespoons instant coffee in 1/2 cup hot water and add to the flour and salt. Your ornaments will look like gingerbread cookies!

✳ Shorten drying time by baking at 250°F for 5–10 minutes.

**Recycled Materials**

# Reuse & Recycle

Using recycled materials builds children's awareness of conservation and helping the environment. Plus, the materials are usually free! You'll need to prepare these materials in advance for children's use.

## Sewing Cards

**Materials:** cardboard boxes, scissors, hole punch, yarn, tape

**How To:**

1. Cut the front section off boxes. Hole-punch around the edges.

2. Take an 18-inch length of yarn. Tie one end to a hole in the box.

3. Twist tape around the end of the yarn to make a "needle," and invite children to sew away!

## Puzzles

**Materials:** cereal boxes, scissors, self-sealing bags

**How To:**

1. Cut the front panels off the cereal boxes.

2. Cut panels into puzzle shapes. Then put them back together. Store in self-sealing bags.

**And...**

✳ Adjust the number of pieces to children's ability.

✳ If you have two like boxes, cut up one, then let the children put it back together on top of the one that is not cut up.

✳ Let children make their own box top puzzles.

# Cardboard Castle

**Materials**: empty food boxes, masking tape

**How To**:

1. Have children collect boxes in any sizes at home, then bring them to school. Each child will need at least five boxes.

2. Place the boxes and masking tape in the block center and let children build away!

**And...**

☀ Have children paint the boxes.

# Concentration

**Materials**: miniature cereal boxes, scissors

**How To**:

1. Cut the front and back panels off the boxes.

2. Mix them up, then ask children to match up the fronts and backs that go together.

3. Next, place them facedown on the floor. Let children take turns turning over two cards and trying to match them, as in Concentration.

**And...**

☀ Start with three or four pairs and make the game increasingly complex.

# Stencils

**Materials**: cardboard boxes, scissors, pencils and crayons, paper

**How To**:

1. Cut the front and back panels off the boxes.

2. Cut different shapes from the cardboard.

3. Invite children to trace around the templates with pencils, crayons, markers, pens. Color in the shapes!

**And...**

☀ Tie in stencils with classroom themes, seasons, letters, numbers, shapes, and so on.

# Giant Blocks

**Materials**: large, sturdy cardboard boxes; tape; paintbrushes; paint; scrap box; magazines

## How To:

1. Have each child bring in a cardboard box.

2. Tape boxes shut. Paint the boxes and let dry.

3. Let children decorate boxes with scrap paper, stickers, fabric scraps, magazine pictures, and so on.

4. Sit in a circle with the blocks. One by one, have each child add a block to create a tall stack in the middle of the circle. Knock it down and then build it again. Ask, *How high can you build it? How long? Can you make a tunnel to crawl through?*

## And...

✳ Have children decorate their blocks at home with families.

✳ Empty detergent boxes also work well for this project.

# Kazoos

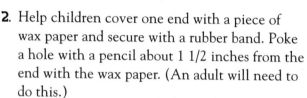

**Materials**: cardboard rolls, wax paper, rubber bands, markers or crayons, pencil

## How To:

1. Have children decorate the cardboard roll with markers or crayons.

2. Help children cover one end with a piece of wax paper and secure with a rubber band. Poke a hole with a pencil about 1 1/2 inches from the end with the wax paper. (An adult will need to do this.)

3. Invite them to hum away!

## And...

✳ Ask families to save cardboard rolls for you. For health reasons, request paper towel rolls.

✳ When you need smaller rolls, cut paper towel rolls in half with scissors.

# Puppets

**Materials**: cardboard rolls, construction paper, scissors, crayons, markers, glue

## How To:

1. Let children color and cut out story characters and glue them on the rolls.

2. Have them insert their fingers in the bottom to create a puppet.

## And...

✳ Children can cut out pictures of people or animals from magazines and glue them onto the rolls.

# Boat

**Materials:** two cardboard rolls, glue, tape, craft stick, construction paper

**How To:**

1. Help children tape two rolls together (side by side).
2. Help them wrap with masking tape to secure.
3. Invite them to decorate a triangle for a sail and glue to a craft stick.
4. Show them how to insert the sail between the two rolls. (This boat will actually float!)

# Spyglasses

**Materials:** cardboard roll, colored cellophane, rubber bands, markers or crayons

**How To:**

1. Have children decorate the cardboard roll with markers or crayons.
2. Help them cover one end with colored cellophane and secure with a rubber band.
3. Invite them to look at objects in the room, or take nature walks with their spyglasses.

# Microphones

**Materials:** cardboard roll, construction paper, tape, glue, foil, paper towels

**How To:**

1. Help children cover the roll with construction paper and tape in place.
2. Place a sheet of foil on the table.
3. Help children wad up two paper towels and push them into one end so they stick out a little.
4. Show them how to bring ends of foil around paper towel ball and twist. Glue onto the roll. Sing songs, recite poems, or tell stories with the microphone!

**And...**

✱ If a child is talking too softly, say, "You'll have to turn up the microphone a little so I can hear you."

# Party Favor

**Materials:** cardboard roll, tissue paper, ribbon, stickers, small toys, candy

**How To:**

1. Help children put candy, gum, or small toys in the cardboard roll.
2. Help children wrap in tissue paper and secure with a sticker.
3. Help children tie ribbons around the ends. Give away as party favors!

Paper Plates

# Paper Plate Projects

You'll be amazed at how many things kids can do with paper plates. Inexpensive white paper plates work best for these projects.

## Fish

**Materials**: paper plates, scissors, glue, crayons, markers, wiggle eyes

**How To**:

1. Tell children to fold the plate in half and color each side with "scales."

2. Have children cut fins and a tail out of construction paper and glue in place.

3. Let children glue on wiggle eyes and draw a mouth. The fish can stand up on its own.

## Visor

**Materials**: paper plates, scissors, hole punch, markers, string

**How To**:

1. Have children cut a crescent shape from the paper plate. Let them decorate, then hole-punch each end.

2. Tie a foot-long piece of string to each hole and adjust to the size of each child's head.

## Clock

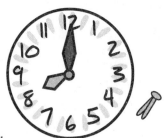

**Materials**: paper plates, brad fasteners, pencil, crayons, construction paper, scissors

**How To**:

1. Write numbers around the edge of the plate with a pencil.

2. Have children trace over the numbers with a crayon.

3. Cut out a small hand and a large hand from construction paper. (Use two different colors.)

4. Attach to the center with a brad fastener.

# Lei

**Materials:** paper plates, scissors, colored tissue paper, glue

**How To:**

1. Cut out the rim of the plate.

2. Have children tear tissue paper into small pieces and wad gently.

3. Let children dip in glue and stick to the plate. Let dry.

4. Cut to place around children's necks, like collars.

**And...**

✴ Make a clown collar in a similar way, using pom-poms or construction paper cut into circles.

# Turtle

**Materials:** paper plates, scissors, construction paper, markers or crayons, brad fasteners

**How To:**

1. Tell children to color the paper plate to resemble a turtle shell.

2. Have children cut out legs, head, and a tail from construction paper.

3. Help children attach with brad fasteners.

# Mask

**Materials:** paper plates, scissors, construction paper, markers, scissors, large craft sticks

**How To:**

1. Cut holes for eyes out of the paper plate.

2. Have children decorate the plate with markers and construction paper to look like an animal, person, or other character.

3. Attach a jumbo craft stick to create a mask.

**And...**

✴ Make masks to dramatize favorite songs and stories, such as "The Three Billy Goats Gruff," "Old MacDonald's Farm," "The Little Red Hen," and so on.

# Bird's Nest

**Materials:** paper plates, straw or cellophane grass, construction paper, stapler, crayons

**How To:**

1. Have children fold the plate in half and staple closed.

2. Let children color the plates to look like nests.

3. Then they cut a slit in the folded edge and insert straw or grass.

4. Invite children to make a bird from the construction paper and insert in the slit.

# Mouse

**Materials:** paper plates, scissors, construction paper, markers, glue, yarn, stapler, hole punch

**How To:**

1. Have children fold the plate in half and staple shut.

2. Let them color the plates, adding details for the eyes, nose, and whiskers.

3. Children can cut out large ears and glue in place.

4. Help them punch a hole and tie on a piece of yarn for a tail.

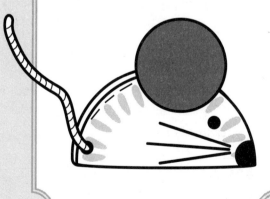

# Pumpkin

**Materials:** paper plates; construction or tissue paper in orange, green, and yellow; glue

**How To:**

1. Let children tear orange paper into tiny pieces and glue onto the plate.

2. Have children add a green stem and use yellow paper to make eyes, nose, and a mouth.

Paper Plates

# Tambourine

**Materials:** paper plates, stapler, markers, dry beans, tissue paper, glue

**How To:**

1. Let children decorate two paper plates with markers or crayons.

2. Staple around the outside edge, leaving a three-inch opening to insert the beans.

3. Insert a small handful of beans and staple shut.

4. Have children glue on some tissue paper streamers and dance away!

# Snake

**Materials:** paper plates, markers or crayons, scissors

**How To:**

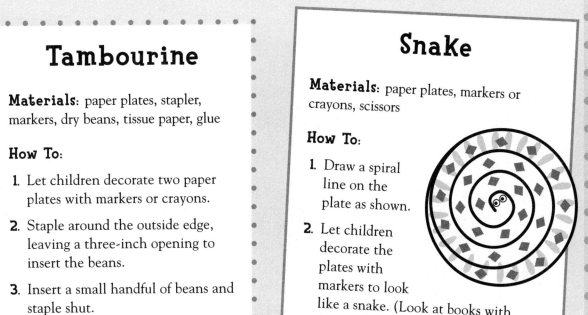

1. Draw a spiral line on the plate as shown.

2. Let children decorate the plates with markers to look like a snake. (Look at books with pictures of snakes to see the markings.) Help them cut on the spiral line, then hold the snake by its head and dangle.

# Kite

**Materials:** large paper plates, string, markers, scissors, tissue paper or crepe paper, hole punch

**How To:**

1. Have children cut a large hole in the middle of the plate.

2. Let them decorate the resulting O-shape with markers or crayons.

3. Children then cut tissue paper or crepe paper into strips and glue to the plate, then punch a hole and tie on a long piece of string.

4. They can hold on to the string and run on the playground!

# Paper Bag Fun

There's so much you can do with a simple paper bag! Use lunch bags or grocery store paper bags. Ask families to donate bags from home.

## Tree

**Materials:** paper bags, materials for decorating (see step 3)

**How To:**

1. With bag flat, tear down four strips from the top, halfway down.

2. Open the bag, grab at the bottom, and twist.

3. Fluff up strips to look like branches on a tree. Let children decorate one of these ways:

   ✳ Make a "letter tree" by writing letters on the strips.

   ✳ Tear orange, yellow, and red construction paper into little pieces and glue on the branches to make an autumn tree.

   ✳ Twist strips to look like a bare tree in the winter. Use a sponge to add white paint to the branches. Sprinkle with glitter.

   ✳ To make a spring tree, tear little pieces of pink or white tissue paper. Dip in glue and attach to the branches.

## Nest

**Materials:** paper bags, glue construction paper, scissors, materials for decorating

**How To:**

1. Open the bag. Slowly roll out and down.

2. As you squish toward the bottom it will begin to resemble a nest.

3. Have children cut birds from construction paper for the nests.

4. Children can glue strips of yarn, string, or other collage materials to the nests.

**And...**

✳ Take a nature walk and have children collect leaves and straw to glue to the nest.

**Paper Bags**

# Houses

**Materials**: paper bags, construction paper, markers, newspaper, glue, stapler

**How To:**

1. Decorate the bottom half of the bag to look like a house.

2. Ball up a sheet of newspaper and stuff it into the bag.

3. Fold over the top of the bag and staple on construction paper for a roof.

**And...**

✳ Turn a bag open side down and let children draw a house or building on it. Take a second bag and stuff with newspaper. Pull the first sack over the second sack to make a stand-up building to use as a prop in the block center.

# Kites

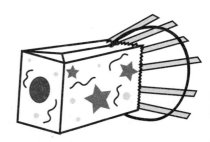

**Materials**: paper bags, scissors markers, string, tissue paper, glue, hole punch

**How To:**

1. Have children decorate the entire bag.

2. Help children cut a 1 1/3-inch circle from the bottom of the bag.

3. Glue tissue paper streamers to open end of the bag.

4. Punch holes in the sides of the bag and attach string through the holes as shown.

# Baskets

**Materials**: paper bags, stapler, scissors

**How To:**

1. Have children tear off the two sides and open the bag. They cut off the top half of the front and back panels.

2. Help children staple ends of the middle strip to create a handle for the basket.

**And...**

✳ Use baskets for nature walks, a popcorn party, May baskets, as a mailbox, and so on.

# Small-Motor Skills

Building manual dexterity and hand-eye coordination are important parts of children's early learning. All of the art projects in this book help develop fine-motor skills, but they also require children to apply the fine-motor skills they already have. The activities in this section help children do both! Also included are helpful tips and tricks for using scissors, pencils, and glue.

## Scissors

Remind children to keep "thumbs up" when they hold scissors! Tell them to hold the paper with one hand and take tiny little bites with the "jaws" of the scissors.

## Glue

Explain to children that when you use glue, you should use only a "baby dot, not a lot!" They'll also remember with this song to the tune of "This Old Man."

Glue glue glue,

Glue glue glue,

just a little dot will do.

Put a dot here
and spread it all around.

It will hold all your things down.

### And...

✳ Try using glue sticks, or pour white glue onto paper or plastic plates and let children use cotton swabs to apply their glue.

# Pencils

Each child will need a cotton ball, pom-pom, or small ball of play dough for this trick. Place the cotton ball in the palm of their hand and tell them to hold it down with their pinkie and ring finger. (Explain that it is "magic" and will help them write.) Next ask them to pick up their pencil. They will have the correct grip!

## Hint!

You can make a pencil grip by wrapping a rubber band over and over around the end of the pencil.

# Where Is Pointer?

Teach children this song (to the tune of "Where Is Thumbkin?") to identify the pencil tip, thumb placement, and eraser.

Where is pointer? Where is pointer?

On the top. On the top.

Ready to write. Ready to write.

Start at the top. Start at the top.

(Where is Thumbkin?...On the side... Ready to help...Your pencil glide.)

(Where is Tall Man?...On the bottom... Keeps the letters...Where you want 'em.)

# Play Trays

**Materials**: lunchroom trays, play dough and cookie cutters, hole punch and scrap paper, puzzles, stencils, beads and yarn, and similar manipulative materials

## How To:

1. Place several lunch trays on a table. Put a different manipulative material (as described on pages 46–48) on each tray.

2. Encourage children to focus on the materials and complete the fine-motor tasks on each tray.

## And...

✳ Use cookie sheets and magnetic letters for a "spelling" play tray.

# Stringing

**Materials**: yarn, masking tape, cereal with holes

## How To:

1. Tape the end of the yarn to make a needle. Have children string cereal on yarn.

2. Tie ends of the yarn together to make a necklace.

## And...

✳ String cereal on pipe cleaners. Twist to make a circle and hang on branches for a bird feeder!

✳ Cut straws into one-inch sections and let children string them onto a length of yarn for a necklace.

✳ Use dry pasta with holes to string on yarn or cord.

✳ Heavy dental floss or plastic cord also work well for stringing activities.

# Weaving

**Materials**: plastic berry baskets, yarn or string

## How To:

Let children weave string and yarn through the holes in a berry basket.

## And...

✳ Attach a pipe cleaner handle to baskets when complete.

✳ Cut notches in the sides of a paper plate or piece of cardboard and let children weave around with colored yarn.

# Stencils

**Materials:** plastic lids, scissors, colored pencils, paper

**How To:**

1. Cut shapes and objects out of plastic lids.

2. Children can trace around the stencils with colored pencils or pens.

# Bottles

**Materials:** plastic bottles with wide necks, cotton balls, pom-poms

**How To:**

1. Fill plastic bottles with pom-poms or cotton balls.

2. Challenge children to use their fingers to remove the objects. They can put them all back in the bottle when they're finished.

**And...**

* Offer tweezers for the task of removing the cotton balls or pom-poms.

# Rainbow Letters

**Materials:** letter-shaped pasta, rubbing alcohol, food coloring, wax paper, paper, glue

**How To:**

1. Separate the pasta into four plastic bags. Add a tablespoon of rubbing alcohol and a squirt of food coloring to each bag and shake.

2. Dry on wax paper.

3. Let children sort through the pasta and find the letters in their name, then glue them to paper.

**And...**

* Provide children with child-safe magnifying glasses and tweezers to help them find the letters they need.

# Tweezers & Tongs

**Materials:** tweezers, tongs, pebbles, small toys, crayons, popped popcorn, dry beans

## How To:

1. Place two paper plates or boxes on a tray. Fill one with objects similar to those above.

2. Children transfer all the items from one plate or box to the other using the tongs or tweezers. (Offer tongs for larger objects and tweezers for small items.)

# Pounding

**Materials:** plastic hammers, golf tees, large pieces of foam packing

## How To:

Let children pound golf tees into the foam with plastic hammers.

## And...

✱ Offer plastic knives for sawing.

# Puzzles

**Materials:** old calendars or magazines, tagboard, glue, scissors, self-sealing bag

## How To:

1. Let children select a picture that they like and glue it to the tagboard. Cut the picture into several pieces to make a puzzle. (You may need to limit the number of pieces they can cut.)

2. Store the pieces in the self-sealing bag. Let children exchange puzzles and try to put each other's pictures together.

# Sewing

**Materials:** plastic place mats, hole punch, shoelaces

## How To:

1. Hole-punch around the edges of the place mats.

2. Let children sew around the edges with shoelaces.

## And...

✱ Purchase place mats with interesting objects and cut them out before turning them into sewing cards.

✱ Let children sew with plastic needles on burlap.